Playful Patterns
HAPPY RHAPSODY

art UNPLUGGED

A NATURAL SOURCE OF HEALING

This EXPERIENCE belongs to:

Look for the entire series of art-unplugged journals.

ISBN: 1940899052 (Playful Patterns)

Printed in the United States of America

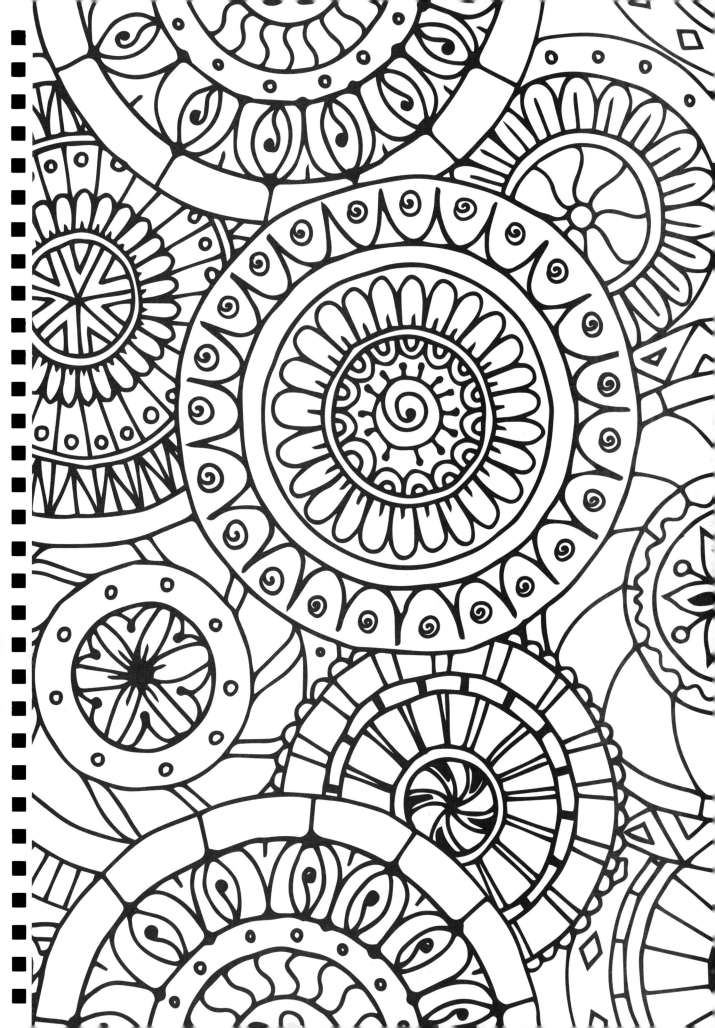

Think about where you believe your happiness comes from. Do you think it comes from within, or from your exterior environment and relationships? Both sources are valid. It is helpful to be aware of what creates happiness in your life so you can be intentional about seeking it and accepting it.

Sources of my happiness are:

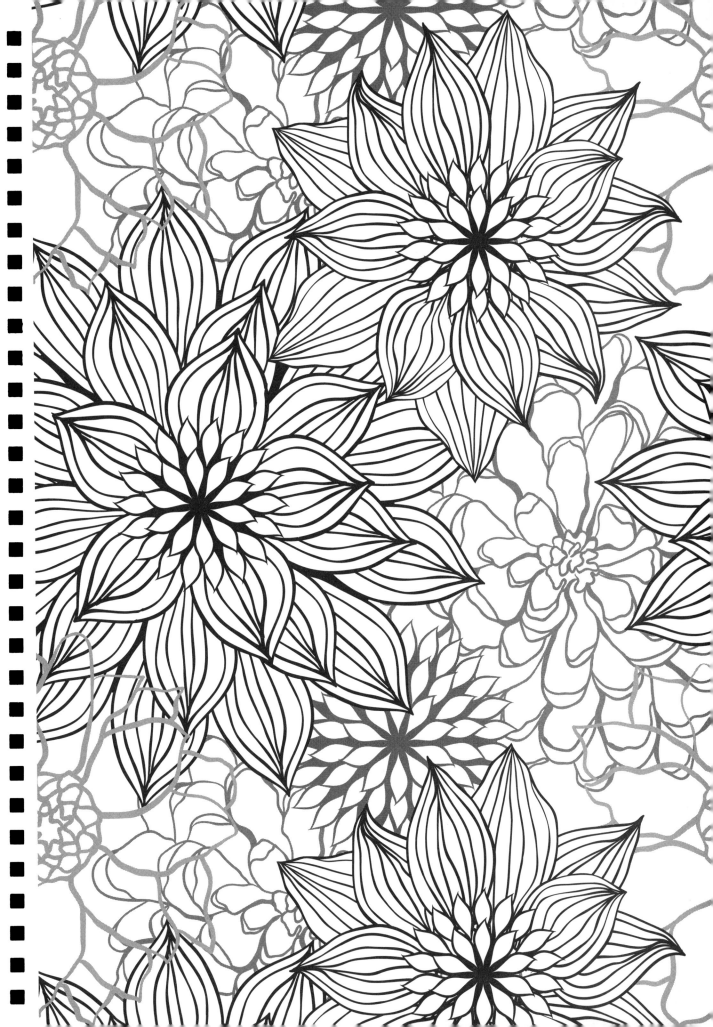

What does this picture make you wish for?
Have you ever wished for that before? What
do you believe helps wishes come true?

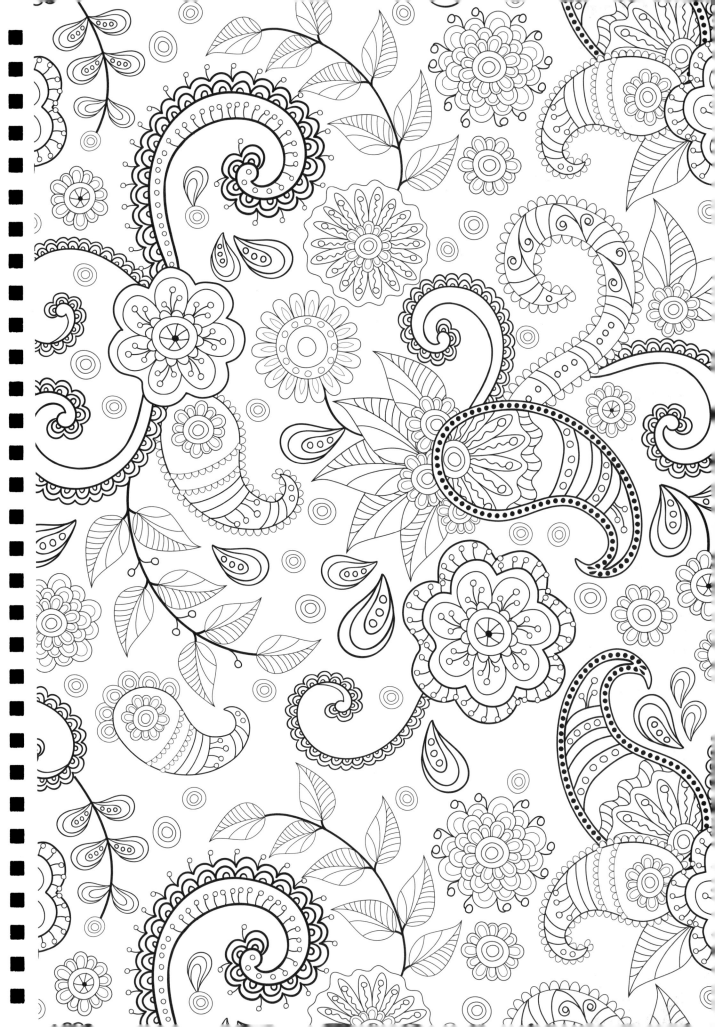

There are many types of happiness. Sometimes it is situational and temporary. Sometimes it is a state of mind and a constant undercurrent of your life. Write about when you have felt each kind. Write about people you know who exhibit a constant state of happiness no matter what their situation. What do you think creates their happiness? Do you admire it or does it irritate you? What kind of reactions do you have to other people's happiness?

Write about the difference between simple sources of happiness and technological sources of happiness. For example, simple sources of happiness might include watching puppies play or listening to babies giggle. High-tech sources of happiness might include watching a comedy on TV or a music video online. Each is valid, and each has pros and cons. Which is easier for you to access?
What are some of the pros and cons of each?

Do you think of yourself as an optimistic or pessimistic person? What do you think others would say you are?

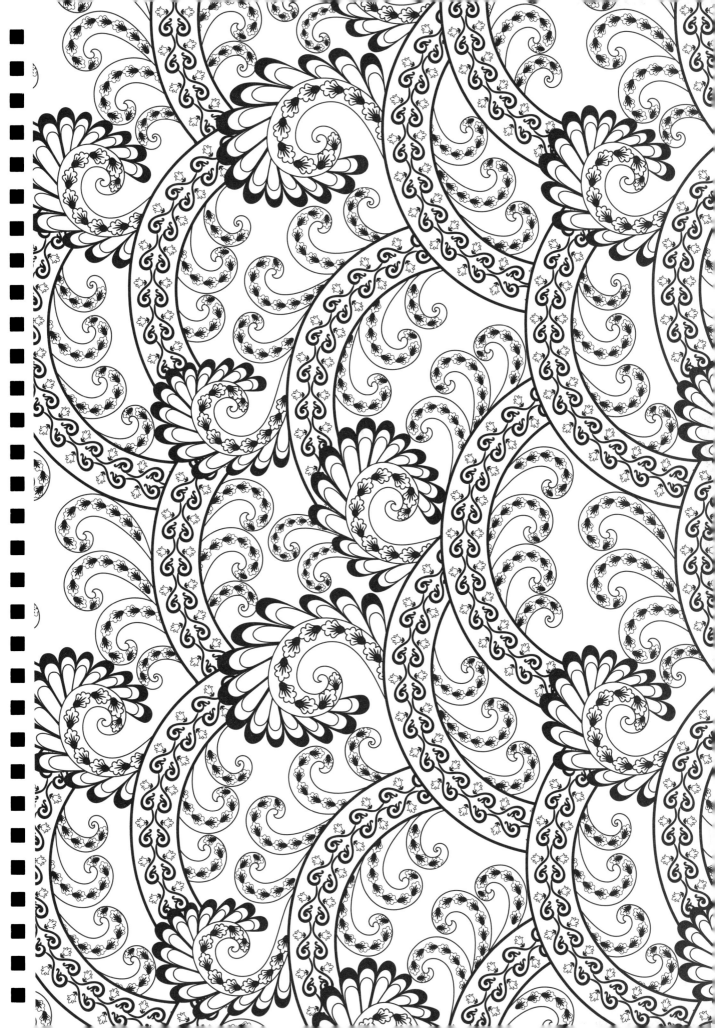

If happiness is a color, what color would it be in your life? What are some colors that make you feel happy and spirited?

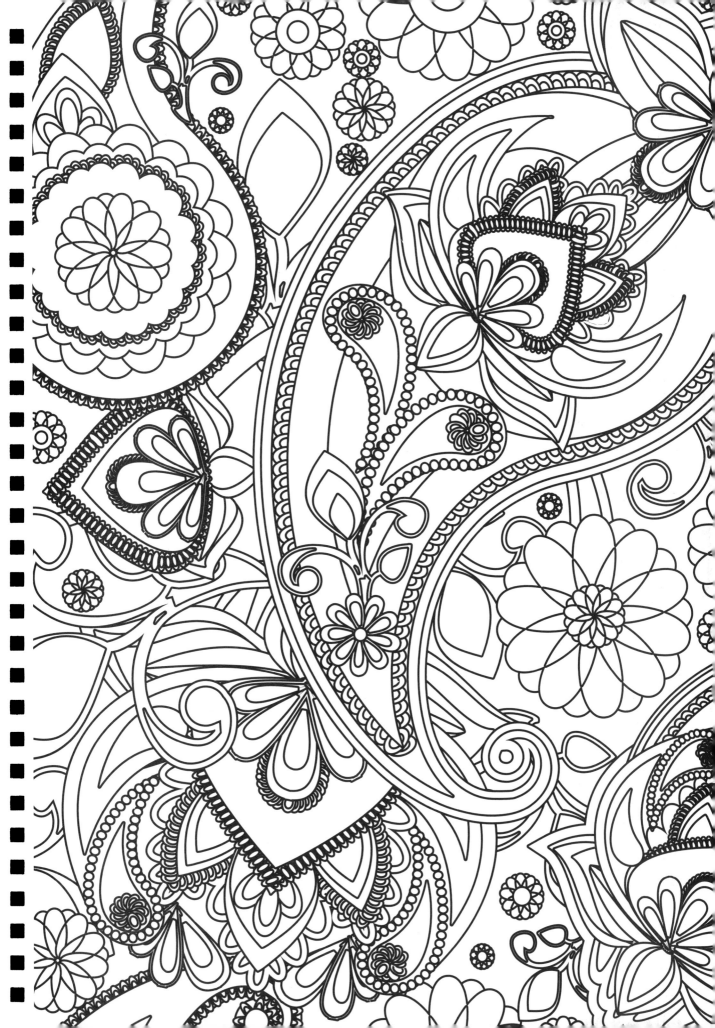

What are some of your fondest memories of playtime? Who were some of your favorite friends and buddies?

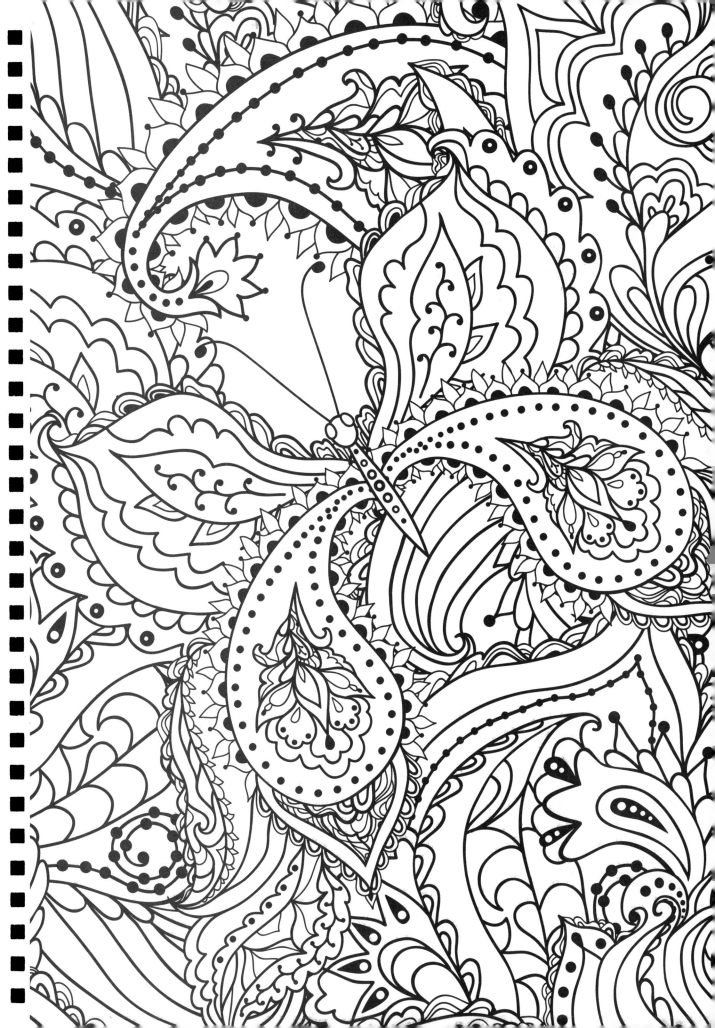

As you color these pages, do your troubles and frustrations melt away? If or when they return, do they seem less troubling and more manageable? Can you get a different perspective on them when you take a break by coloring?

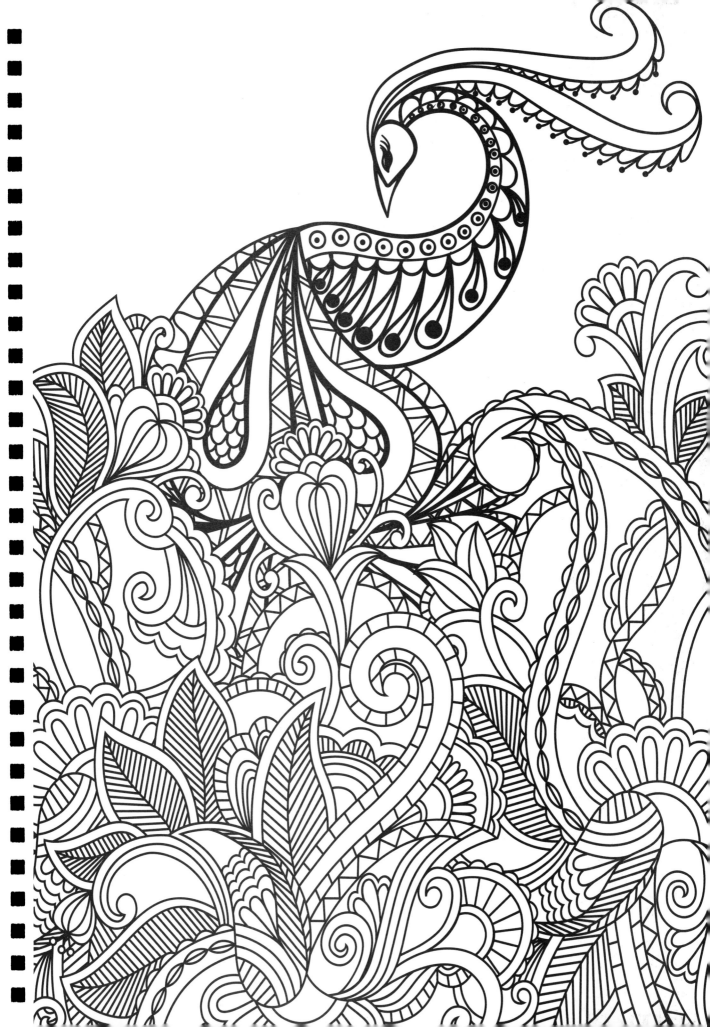

Where is your favorite place to color?
What do you like about this place, and what
makes it special? If you don't have a favorite
place to color, imagine creating a kind of art
studio that would bring out the best in you.
What would it look like?

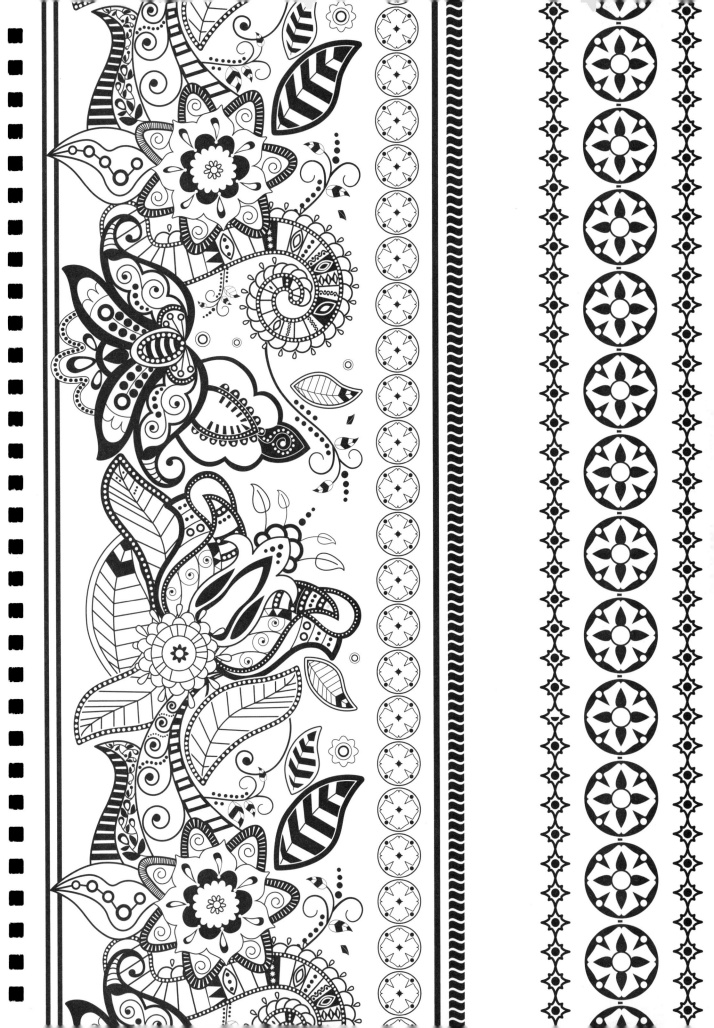

Therapy *is from the original word for healing. How does Art Therapy heal your stress and anxiety?*

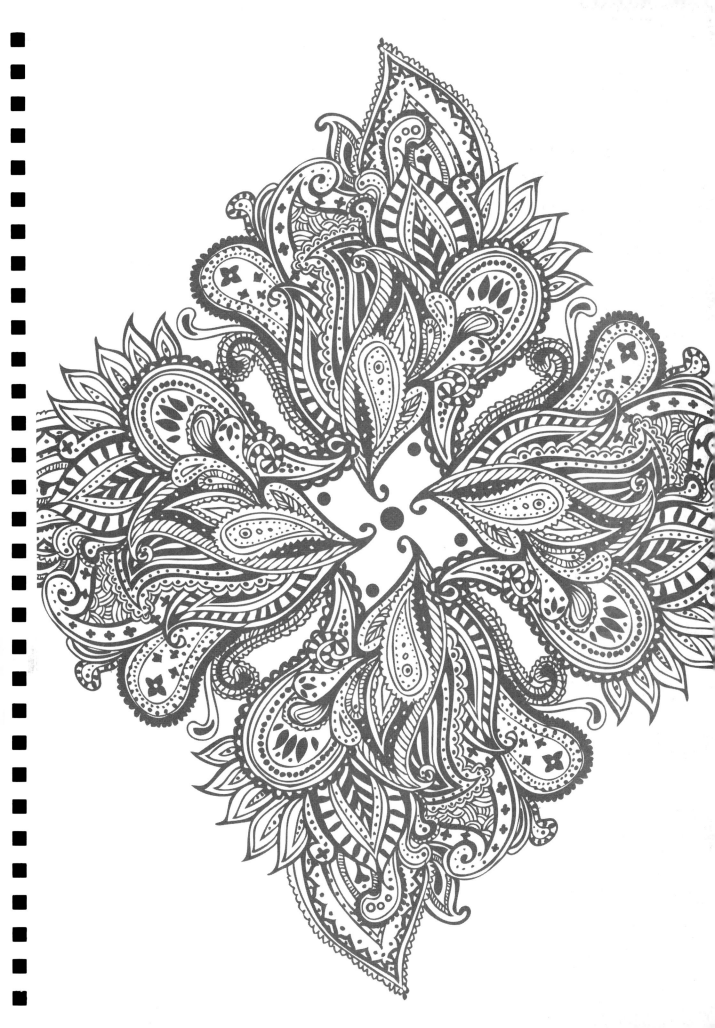

The subtitle of this book is Happy Rhapsody. Another word for rhapsody is enthusiasm. Do you feel enthusiastic about seeking happiness in your life? Write about how you could pursue experiences of happiness.

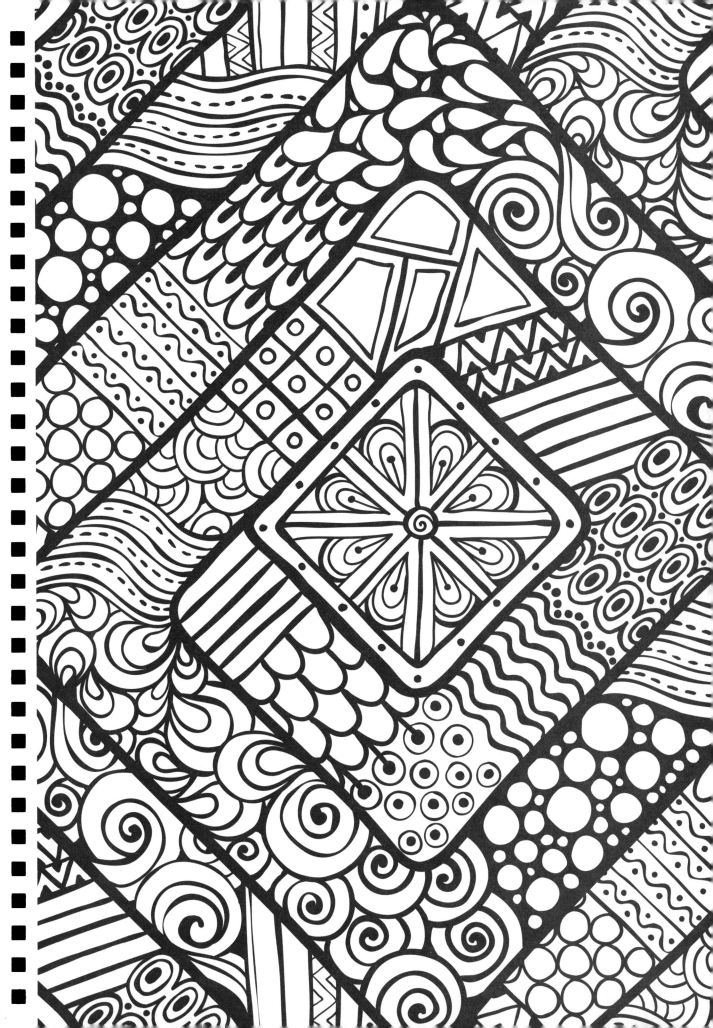

Imagine a life without worry. Hard to imagine, isn't it! How does worry damage your life? Write about this. Are there any benefits to worrying? Describe some.

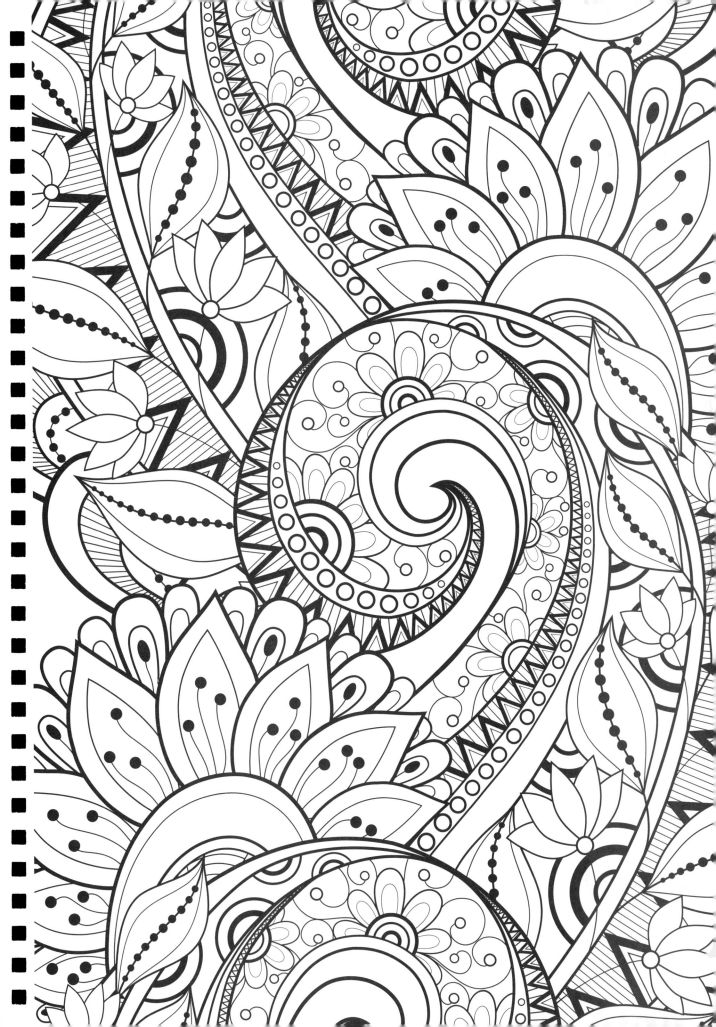

How does coloring these small spaces
create a sense of importance in your life?

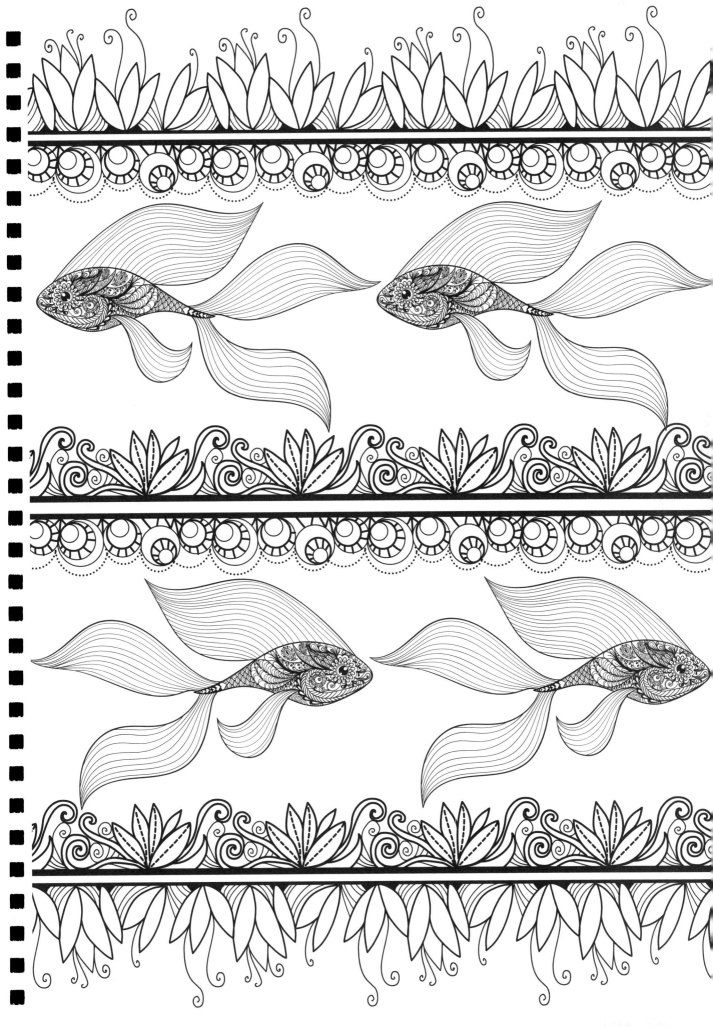

If happiness is a sound, what does it sound like in your Life? What are some sounds that make you feel happy and spirited?

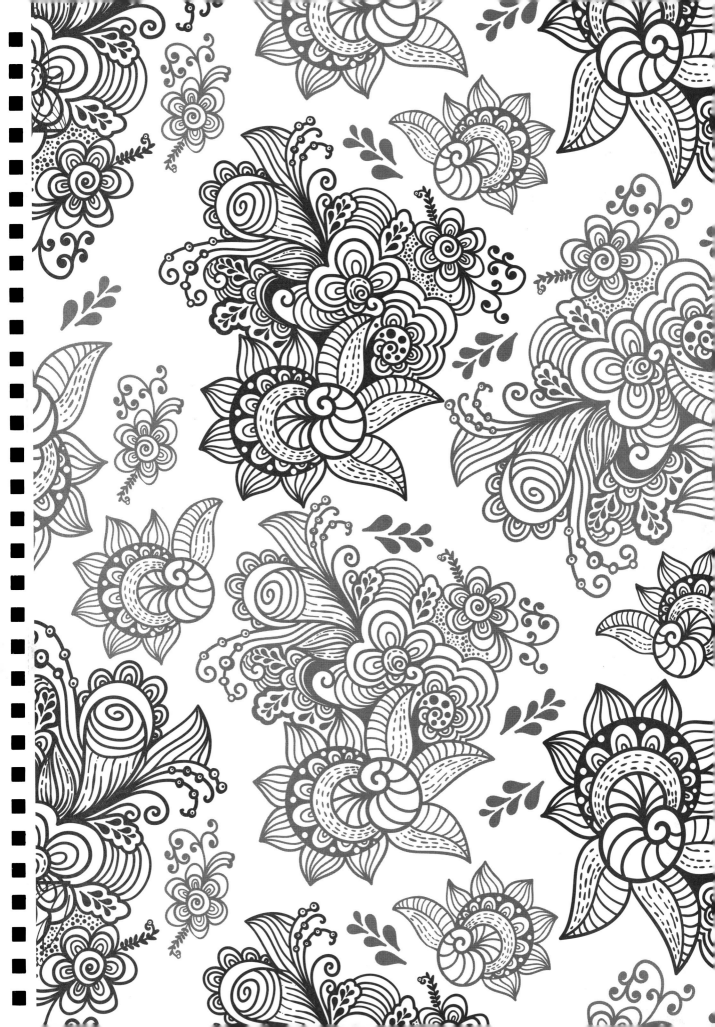

What keeps you from being more "playful" in your day? Does it seem irresponsible? Does it seem like you don't have enough time to play? Do you feel too tired to play? If you answered yes, how can you change your thinking? How can being playful actually be a responsible act of self-care? How can you incorporate playfulness into every moment of your day? Is there a way that being playful can reenergize you when you are tired?

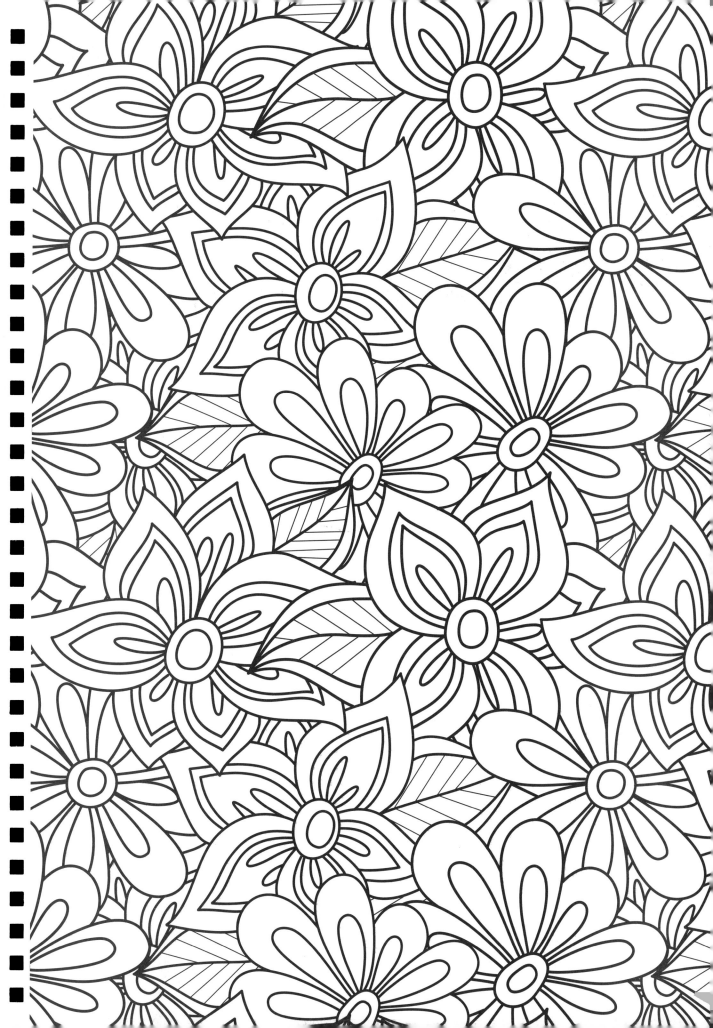

When you work with colored pencils you aren't easily able to erase your work. If you have to live with your choices, how can you turn what you think is a mistake into a new masterpiece? How is this like the rest of your life? How can you turn mistakes into magic?

How does this picture inspire you to be your best? How do you define the word best? Can your best be different from someone else's best? Why does this matter?

Do you find yourself coloring more when you are happy, or stressed? Bored, or nervous? How does coloring help you? How does coloring distract you? Do you consider it a good way to channel your energy?

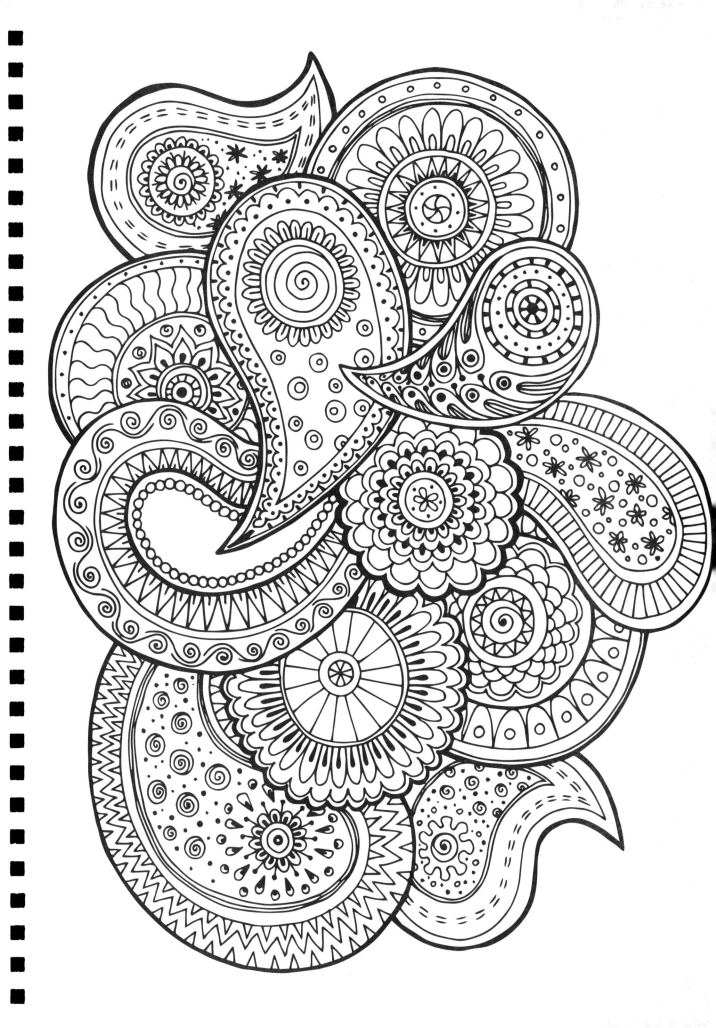

Who or what are some of your inspirations for joy and happiness?

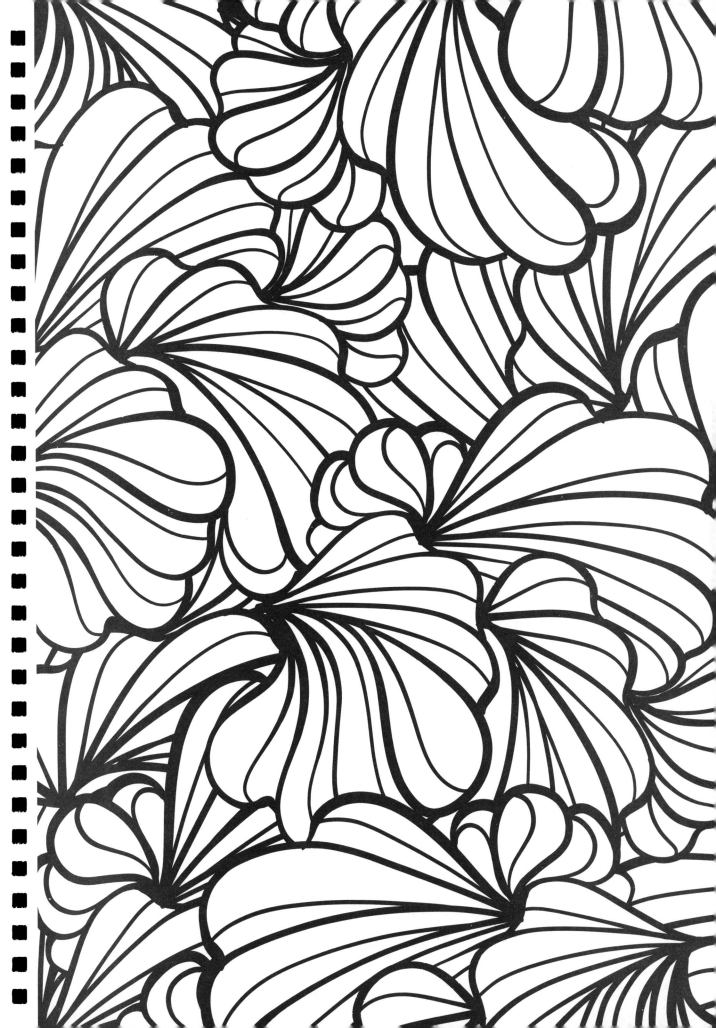

Being unhappy or downcast is sometimes appropriate because of life's events and circumstances. How can you balance your emotions so you don't get "stuck" being unhappy and pessimistic? Who helps you rekindle your joy and hope in your life?

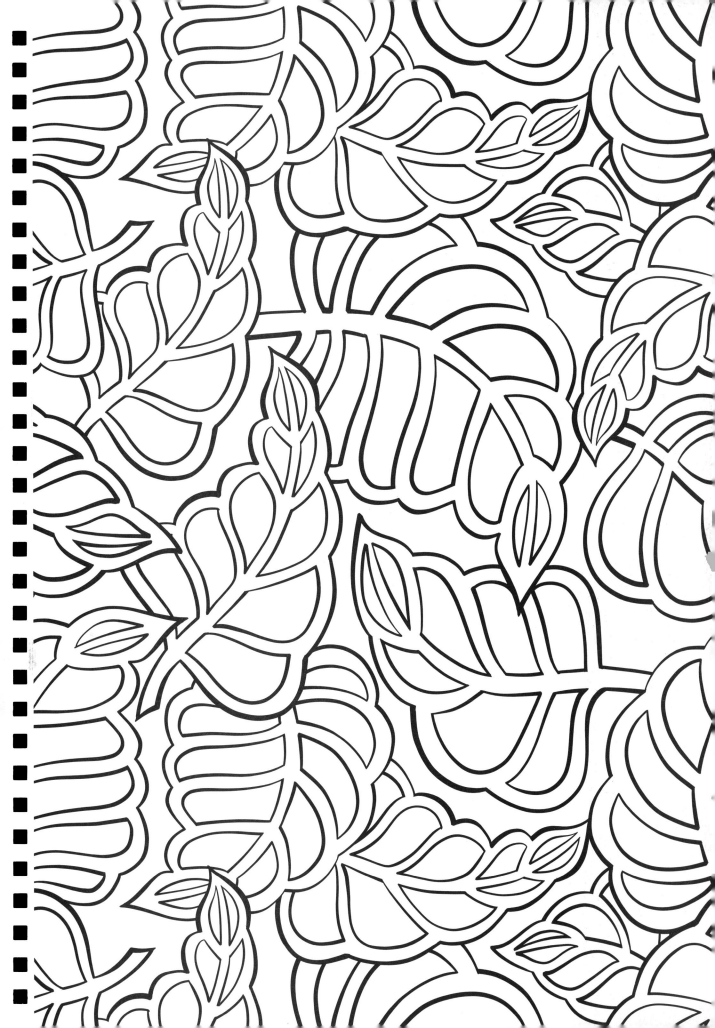

Happiness is more than an emotion. Happiness is an action and intention to align your body, spirit, and mind with your values and beliefs so that conflict and stress are minimized. Write about the situations where you are out of alignment. For example, perhaps your relationships or obligations are inconsistent with what you value most in life. When you become aware of these life circumstances you can consider new courses of action that will result in greater enthusiasm for life. Awareness is the beginning of change!

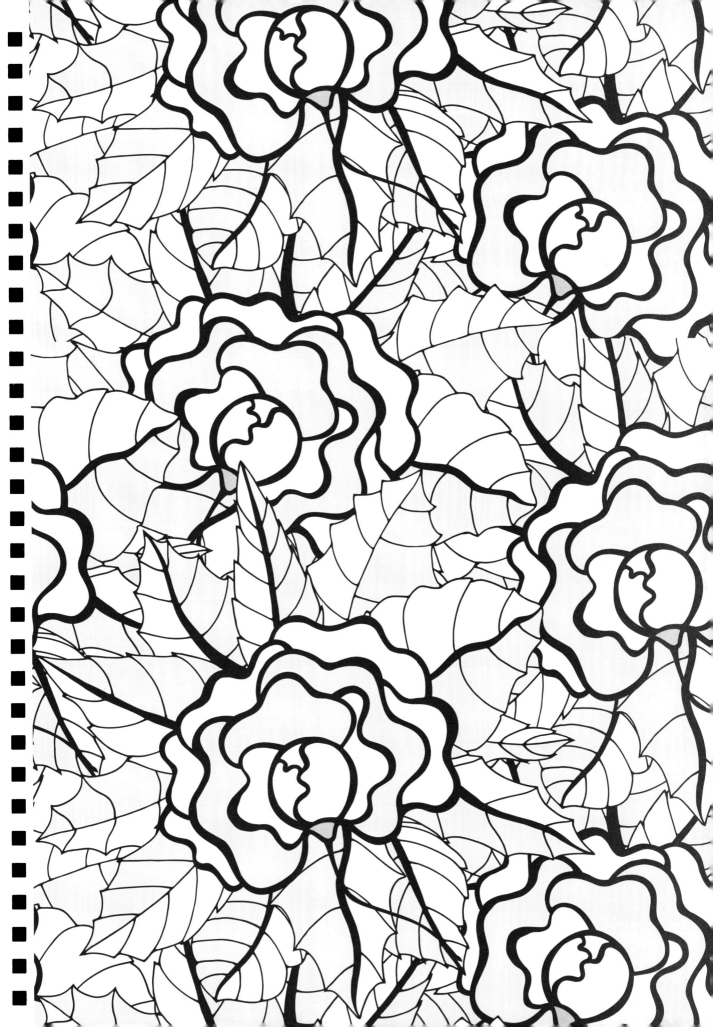

What do you have in common with this picture? Is it happy or serious? Whimsical or realistic?

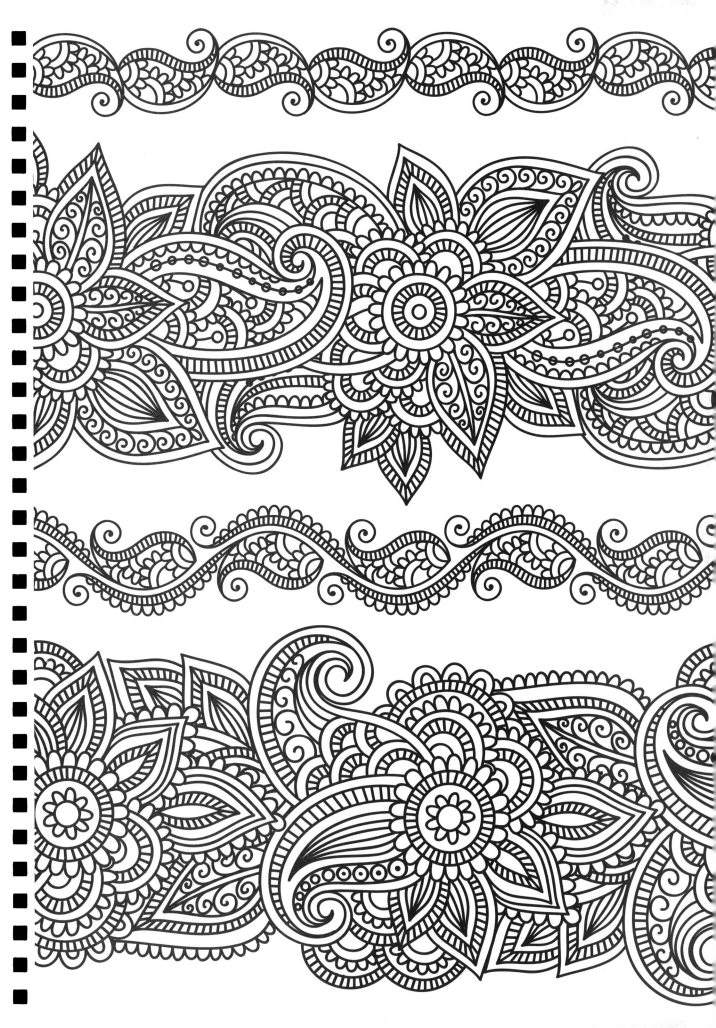

Do you like to color by yourself or with friends? What is better about coloring in the company of others? What is better about coloring alone? Knowing what makes each experience special can help you take better care of yourself.

Write about the last time you felt playful.
What or who encouraged this in your day?
Can you surround yourself with more people
who know how important it is to be playful?

How important do you think happiness and joy are in life? Why?

When you reflect on this picture, think about what you hope for in life. What are your hopes for today?

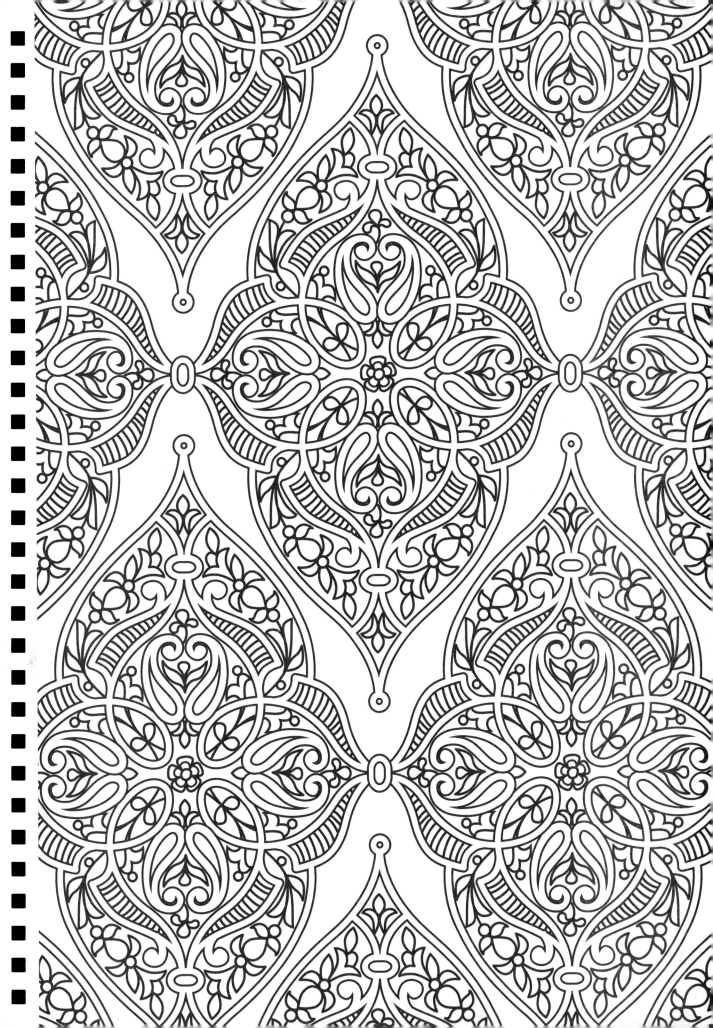

As you color, tap into your feeling of purpose. What else gives you a sense of purpose in life?

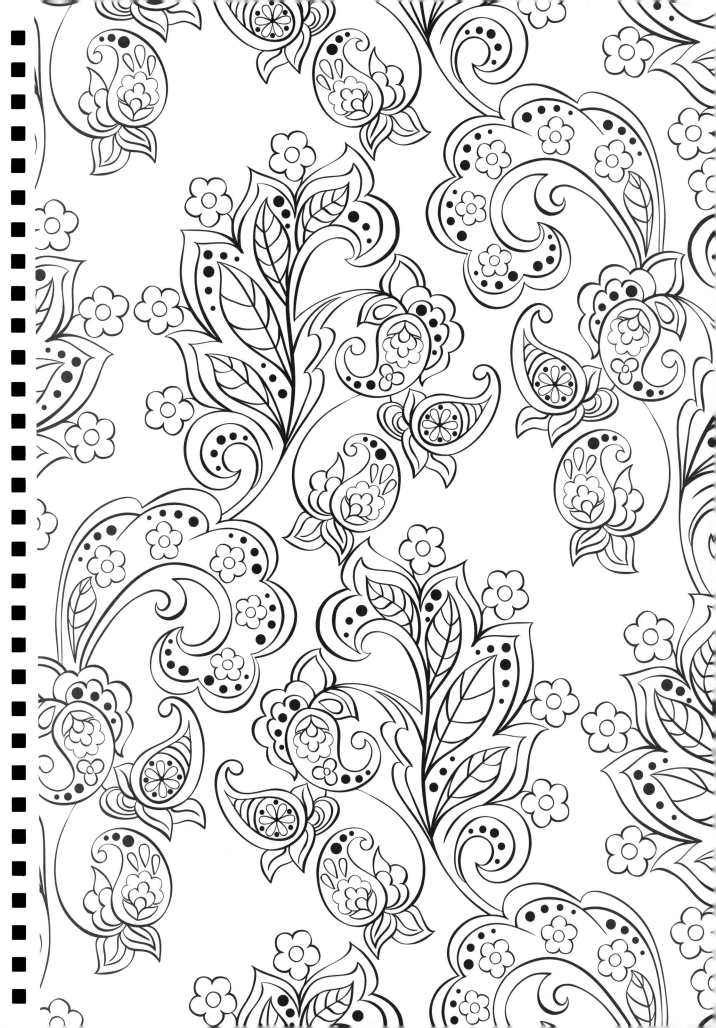

When was the last time you remember playing just to have fun? Describe what you did to be playful and lighthearted.

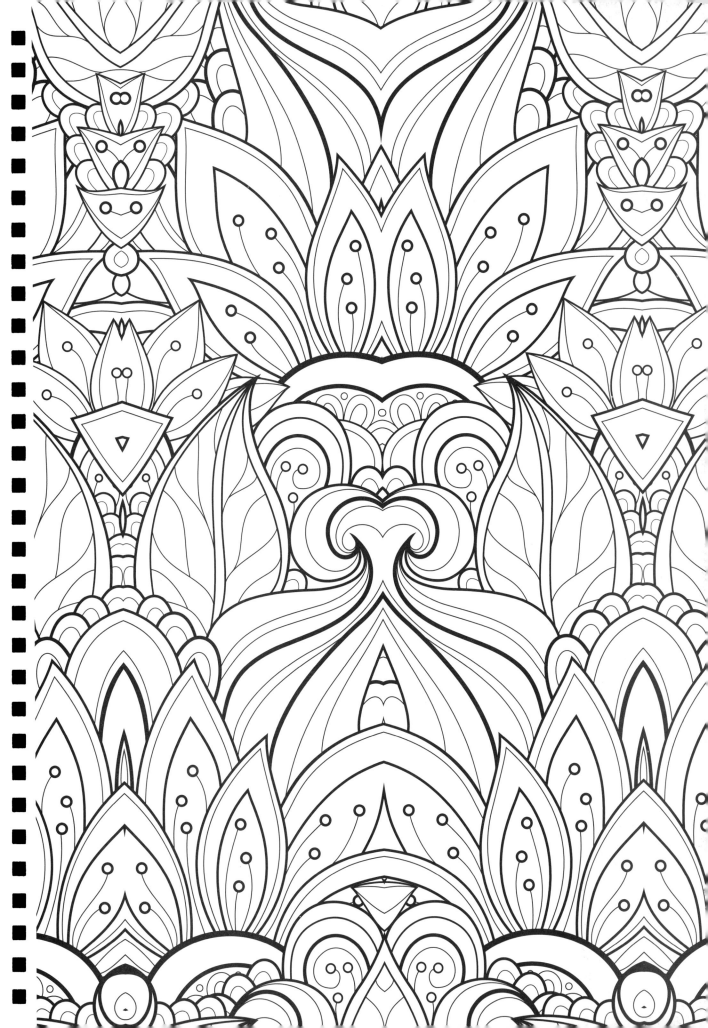

What are some names you could give this picture?

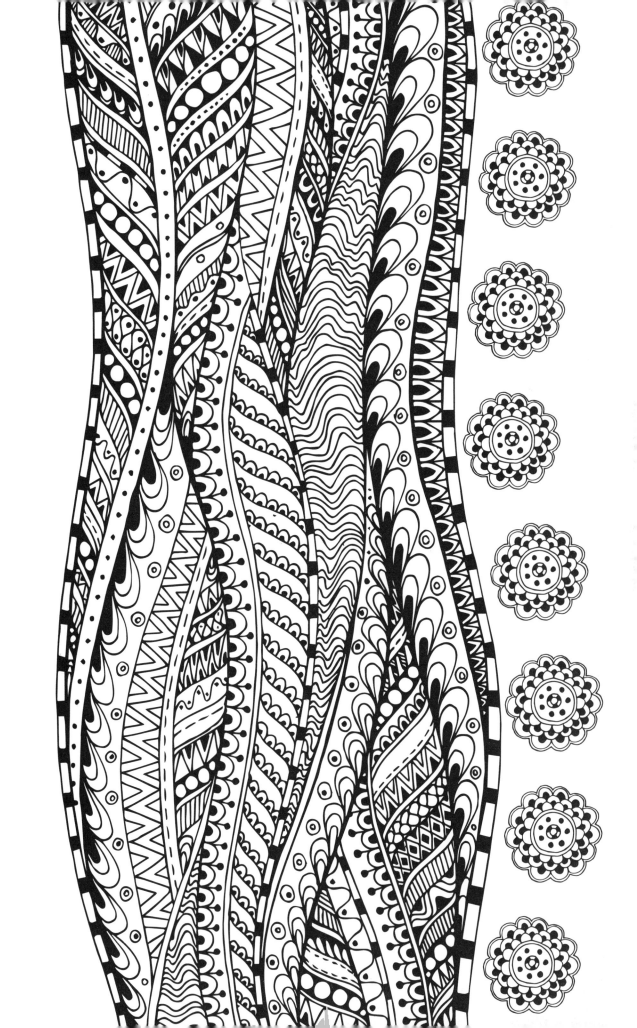

What about this picture brings out the best in you? Does the image look hopeful or kind? Lighthearted or spiritual?

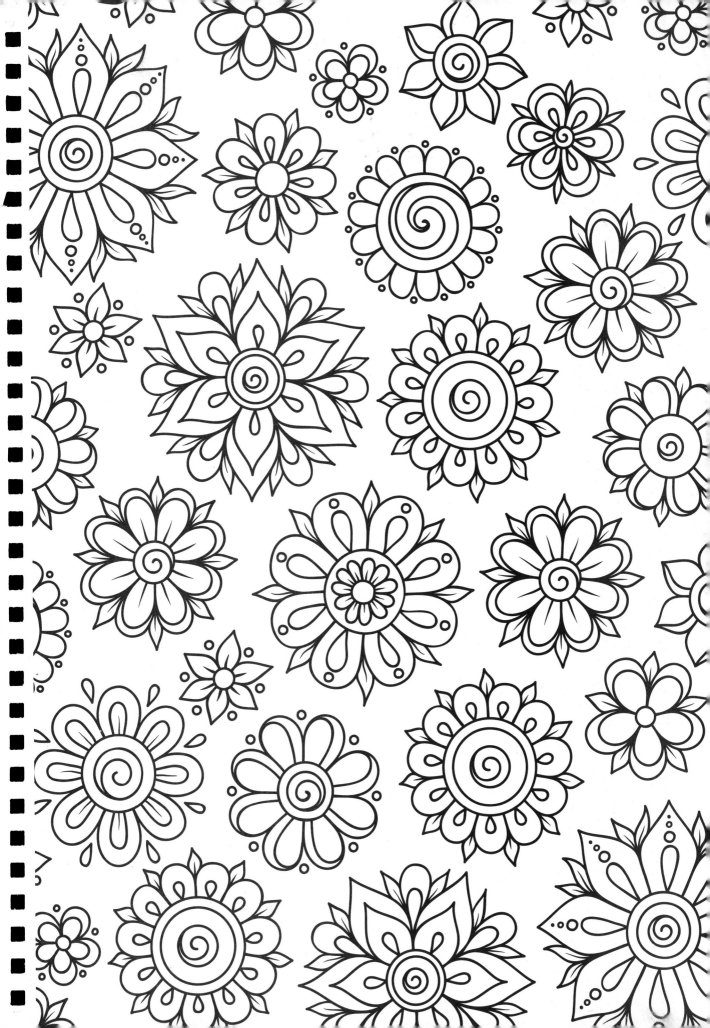

Does coloring calm you and comfort you?
Describe other practices that make you
feel calm.